ALABASTER

Printed in Italy by Graphicom S.r.l.

Contact
hello@alabasterco.com
www.alabasterco.com

Alabaster Co explores the intersection of creativity, beauty, and faith. Founded in 2016. Based in Los Angeles.

My Mom's
Testimony

Table of Contents

"If you are able to talk about your
life and the joys and sorrows you have
experienced, if you know your story, you are
much more likely to be a skillful parent."

Archbishop Desmond Tutu

Everyone has a story. As we move through life,
moments and people shape us and mold who
we are out of who we were. Caught up in the
day-to-day of our lives, it can be difficult to
step back and reflect on our stories, to trace the
narrative threads woven together over the years.
And it can seem harder still to share our stories
with others. Where do we begin? How can we
meaningfully convey the histories of our lives
to one who wasn't there for it all?

Enter *My Mom's Testimony*, an interactive journal
to guide mothers in sharing their walks with God
in their own words. Motherhood is one of life's
greatest journeys. As we help our children
develop and grow, we too are transformed; our
understanding of the world and faith deepens
and expands. These are the lessons that scripture
urges us to share: "Repeat them again and again
to your children. Talk about them when you are

at home and when you are on the road, when you are going to bed and when you are getting up" (Deuteronomy 6:7). This book is designed to help moms recount the wisdom—the highs and lows, the delights and challenges—learned throughout the years and to explore the connection between motherhood and faith.

Divided into six major sections, *My Mom's Testimony* provides thoughtful prompts to guide you in sharing your story. Whether you complete this journal collaboratively with your child(ren), talking through each question and prompt together, or independently to be shared as a keepsake in the future, remember that this exercise is, at its core, a conversation. It is an opportunity for different generations to come together, to learn and listen. Instead of serving as a formulaic interview, we hope these questions might start a dialogue between parent and child. At the end of each section, you will find a place for concluding prayers. Use this space to write about the experience of walking through the preceding questions. What has God taught you through that process? What are your hopes for those who will read and reflect in the future on the answers you gave?

May this journal help you and your child(ren) draw closer together. And may the reflection and conversations sparked here illuminate the bold and beautiful ways that God has been at work all the days of our lives. *Amen.*

01

Early Faith

"Spirituality is one's lived response to who Jesus is. It is one's way of being Christian, fulfilling your Christian vocation.

Spirituality encompasses words like *ministry, service, relationship, lifestyle,* and *prayer*…In short, it is the Christian's response to life."

Mercy Amba Oduyoye

When did you first come to faith?
Or, if you grew up in the Church, when
did your faith first become real to you?

Was there a particular moment or experience
that led you to explore faith more deeply?

Who introduced you to the Gospel and
how did they come alongside you?

How did your faith in Jesus affect your relationships? Was it a source of commonality and togetherness? Or, did it result in any friction between you and your family and friends?

Were you a part of a church or
faith community at this time? If so,
what was that community like?

Looking back, how would you describe your relationship with Jesus in these early days of faith?

Were there any doubts or
questions you had early on?
How did you navigate them?

How did those around you help you
wrestle with these questions? Were you
encouraged to prayerfully reflect on your
doubts, or was this discouraged?

Concluding Prayers

My Mom's Testimony

Romans 1:12, NLT

"When we get together, I want to encourage you in
your faith, but I also want to be encouraged by yours."

02

Living Out Faith

"Faith shows the reality
of what we hope for;

it is the evidence of
things we cannot see."

Hebrews 11:1, NLT

How have your beliefs shaped the
way you handle everyday challenges?

Can you think of a time when another person showed you radical love? What was that like, and how did it make you feel?

Likewise, describe a time when you showed radical love and/or kindness to another person. How did they respond?

Have there been moments when living out
your beliefs felt particularly difficult or went
against the grain? How did you handle that?

In your experience, how do faith and
community relate to one another?
What did that moment teach you?

What does forgiveness mean to you?
How have you experienced forgiveness
from others? How have you extended it?

What makes you feel hopeful?
How do hope and faith intertwine
with one another in your life?

How do you engage with the practice of prayer? How has your prayer life developed over the years?

Concluding Prayers

"O people, the Lord has told you what is good, and this is what he requires of you: to do what is right, to love mercy, and to walk humbly with your God."

Micah 6:8, NLT

03

Reflecting on
the Bible

"God loved us
before he made us,

and his love has never
diminished and never shall."

Julian of Norwich

What is your favorite book of the
Bible? What makes it your favorite?

Is there a particular biblical figure you
really relate to? What is it about that
person's story that speaks to you?

On the flip side, is there a figure from the
Bible you struggle to understand? If so, why?

Is there a Bible passage through which you
feel God truly spoke to you? What were the
circumstances of that season of your life?

Do you have a life verse or favorite
verse from scripture? If so, which one?

How do you approach reading the Bible—do you follow a specific method or practice?

Which Bible verse has impacted you
most recently? What was it that
particularly stuck out to you?

Do you have a preferred Bible translation? If so, what is it about that translation that you appreciate?

Concluding Prayers

"I am counting on the Lord; yes, I am counting on him. I have put my hope in his word."

04

Becoming
a Mom

"But when I am afraid, I will put my trust in you. I praise God for what he has promised.

I trust in God, so why
should I be afraid? What can
mere mortals do to me?"

Psalm 56:3-4, NLT

Share about the moment you
first learned you would be a mother.
Were you excited? Nervous?

Were there any specific moments during
those early days that stand out as
particularly joyful or overwhelming?

Who did you look to for guidance or
support as you entered motherhood?
Who were your role models?

Did your understanding of your faith change
or evolve as you became a mother? How so?

Do you recall any specific prayers you had for
your child(ren) when they were first born?

How did you incorporate your faith into the
way you nurtured and cared for your child(ren)?

How did you choose your child(ren)'s name(s)? Was there a different name you almost chose instead?

Looking back, do you see any ways God was
shaping or preparing you spiritually through
the experience of early motherhood?

Concluding Prayers

"'For I know the plans I have for you,' says the Lord. 'They are plans for good and not for disaster, to give you a future and a hope.'"

Jeremiah 29:11, NLT

05

Lessons Throughout Motherhood

"In the stillness of quiet,
if we listen, we can
hear the whisper of

the heart giving strength
to weakness, courage to
fear, hope to despair."

Howard Thurman

How has your understanding of motherhood
changed as your child(ren) grew older?

How did you foster a strong relationship
with your child(ren), especially as they
developed their own personalities?

How did you share your faith
with your child(ren)? Did this
approach change as they matured?

What is something *you* have
learned from your kid(s)?

Looking back, what have been some of the
most rewarding aspects of raising children,
and what were the most challenging?

How did you navigate the tension between
letting your child(ren) make their own
choices and guiding them with your values?

How have you seen God's presence
or purpose in the growth and
development of your child(ren)?

As you reflect on your journey as a
mother, how has your relationship with
God deepened or changed over the years?

Concluding Prayers

My Mom's Testimony

Proverbs 22:6, NLT

"Direct your children onto the right path, and
when they are older, they will not leave it."

06

Mom's Favorites

"Connection is why we're here. We are hardwired to connect with others,

it's what gives purpose and meaning to our lives, and without it there is suffering."

Brené Brown

If you were to make a list of books you think everyone should read, what books would be on the list? What is it about those books that had an impact on you?

What songs would make your
"favorites" playlist? Why?

What's the best meal you ever had? What about
that experience particularly stands out to you?

What is your favorite pastime and why?

Is there a place or activity that
makes you feel closest to God?

What does "beauty" mean to you?
What are your favorite examples of beauty?

Who in your life has been a spiritual
mentor to you? What have you learned from
them and how have they walked alongside you?

What public figures (past or present)
have had the most influence on
your life and your faith journey?

Concluding Prayers

My Mom's Testimony

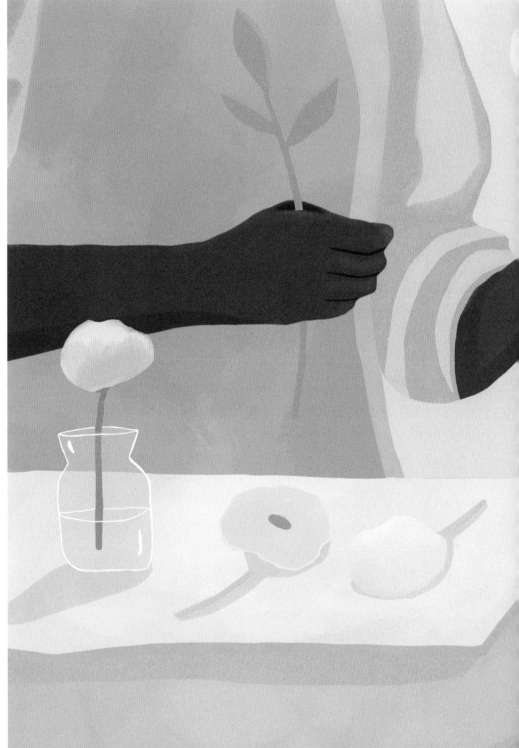

"Fix your thoughts on what is true, and honorable, and right, and pure, and lovely, and admirable. Think about things that are excellent and worthy of praise."

Further Wisdom

*Use this space to expand upon any of your
answers, or to share further thoughts and advice.*

My Mom's Testimony

My Mom's Testimony

Credits

ALABASTER

Team

Brian Chung
Collin Eldridge
Christina Woo
Daniel Han
Ellen Wei
Emaly Tweitmann
Emma Tweitmann
Josh Jang
Joyce Tan
Maria Maddocks
Minzi Bae
Samuel Han
Tyler Zak
Valerie Hui
Willa Jin

Artwork by

Katie Waiyu, 2025